ACPL ITEM
DISCARDED

OVERSIZE

creative
crayon
techniques

creative crayon techniques

Maggi Bennett/ Sarajean Capua/ Jeanette McArthur

Published by Dukane Press, Inc.
Hollywood, Florida

The crayon picture shown on this page
was made on a piece of 1/8" masonite
covered with white masonry paint.
Crayons and a solvent were used in
the technique described on page 28.

contents

Copyright© 1970 by Jeanette McArthur
All rights reserved
Printed in the United States of America
Library of Congress Catalog Number: 72-127619
First Edition
ISBN: 0-87800-028-3

W 1729931

Crayon is a name originally given to any solid stick of colored clay, chalk or wax used for drawing. Natural black chalk (impure carboniferous slate) was used as early as the 14th century and was a standard drawing medium of the Renaissance period. Red chalk (an iron oxide) was used by Leonardo da Vinci and red, black and white chalk were being combined in the 16th century. Seventeenth century artists frequently used oiled charcoal, made by soaking the charcoal sticks in linseed oil to make a rich black mark. The disadvantage of this medium was that it left a greasy ring along the drawing.

Some of the old masters who used crayon were: Michelangelo, Tintoretto, Correggio, Rembrandt and Rubens. Watteau became a master in the use of à trois crayons (the red, black and white combination). Delacroix was a master of black crayon for rapid sketches and for careful preliminary drawings for his paintings.

One of the greatest draftsmen in crayon of the 19th century was Edgar Degas. Toulouse-Lautrec used colored pencils and wax crayons as well as pastels. By the early 20th century, illustrators had begun to use the lithograph crayon for half-tone reproductions and contemporary artists still use various types of crayons for drawing.

Crayon is a very versatile medium and the colored wax variety on the market today is frequently the first art medium which young children use. It lends itself to many different techniques such as: crayon resist, crayon etching, batik and combinations of media. Crayon may be used successfully by the scribbler, the amateur artist and the professional. This book was designed to include the range of varying degrees of advancement.

CLAL/.3.

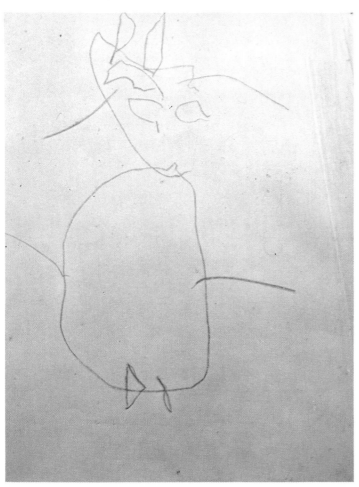

left: Drawing with red wax
crayon by a 2½ year old child.

below left: Picture made with
wax crayons by an artist and
shown in a competitive show in
a New York art gallery.

below: These pictures
were made by a
seven year old child.

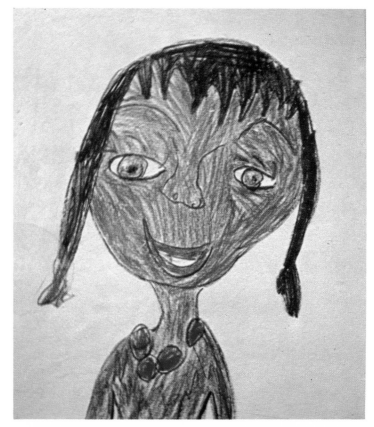

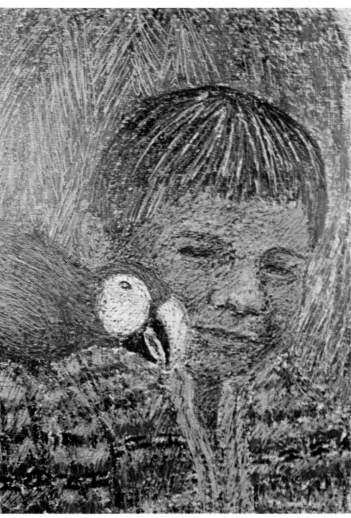

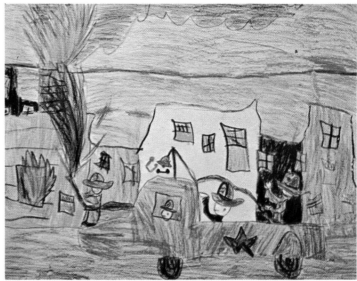

This is the best way to hold a crayon to allow freedom of movement. A broken piece of crayon allows more versatility.

By holding a peeled, broken piece of crayon on the side, a smooth broad stroke can be made.

crayon etching
(dry process)

Use a heavy smooth paper such as tagboard or posterboard as a base for crayon etching. If you want a variety of colors for the undercoat of crayon, white paper will give the colors truer value. Before starting, cover your working area with newspaper to avoid crayon marks on the furniture.

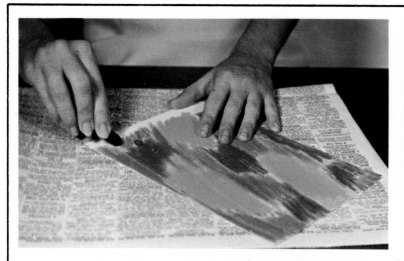

1. Rub a heavy coat of wax crayon on your paper. You may use only one color or a variety. Light colored crayons should be used for greater contrast.

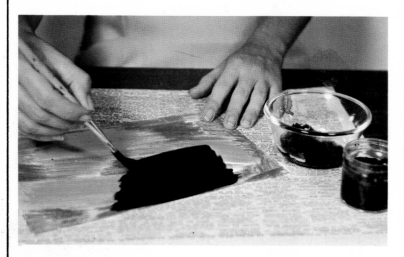

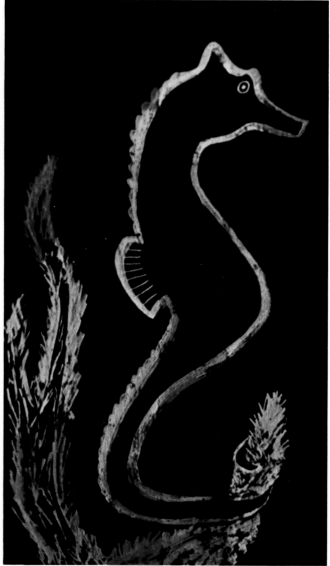

2. When you have covered your paper with crayon, brush over it with black India ink or tempera to which a few drops of liquid soap have been added. Soap causes the ink or tempera to flow smoothly across the waxy surface. Instead of the ink or tempera, black crayon could be used to cover the colored crayon. If ink or tempera is used, allow it to dry, then scratch a design through the top surface with a bobby pin, popsicle stick, scissors or any other pointed tool to expose the colors underneath.

(wet process)

1. For the wet process of crayon etching, begin by coating the paper with wax crayon as described in the dry process. Cover the crayon undercoat with tempera to which a few drops of liquid soap have been added. This top coat may be black or any color dark enough to cover the crayon.

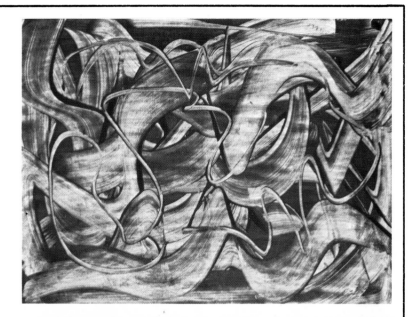

2. While the tempera is still wet, make a design exposing the crayon underneath by using a scrap of posterboard for wide areas and a pointed blunt tool such as an orange stick for lines.

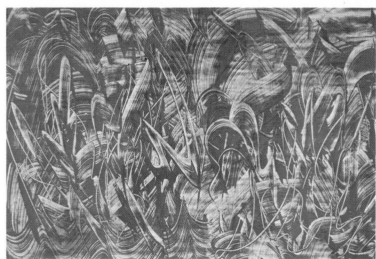

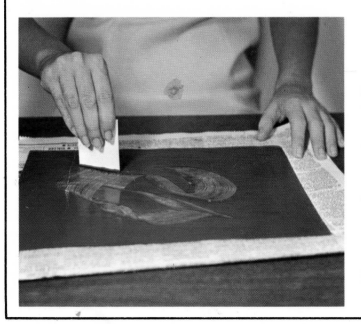

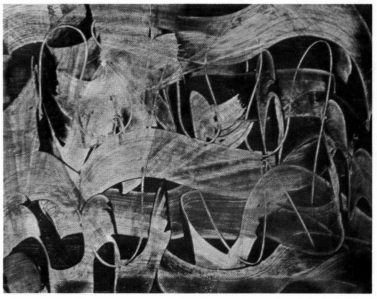

Frottage is a word of French derivation meaning to polish or rub. Any low relief surface may be used for this type of art. To make a crayon frottage, place a sheet of paper over an object with a raised surface and rub with a crayon until the design shows on the paper. To make your own design, cut a shape, abstract or realistic, from a piece of construction paper, manila or tagboard. Place a clean sheet of newsprint or manila paper over the cut out shape. For best results the shape should be simple and easily recognizable by its silhouette. Turn a broken piece of crayon on the side and rub across the design underneath the paper. When the design shows clearly on the paper, move the shape underneath to a different place and continue the rubbing process. For a repeated design, overlap the shape slightly each time.

frottage
(crayon rubbing)

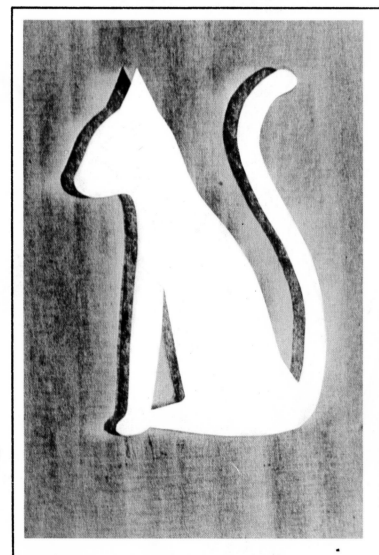
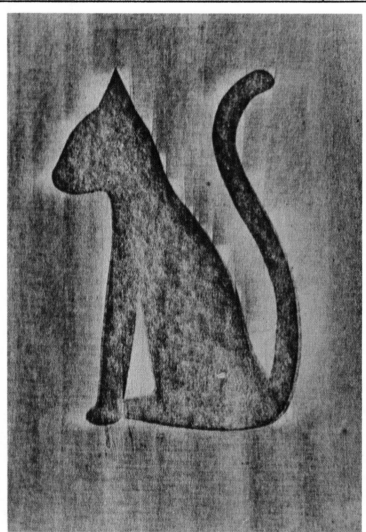

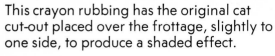

This crayon rubbing has the original cat cut-out placed over the frottage, slightly to one side, to produce a shaded effect.

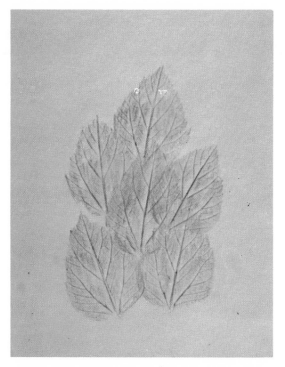

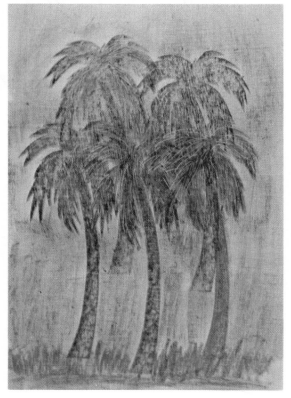

crayon resist

A wax crayon drawing will resist any type of water base paint. Make a crayon design by pressing hard with your crayon to provide a heavy wax coating on your paper. When you have completed your design, brush watercolor or thinned tempera across it. The paint will be absorbed by the areas of paper which have not been covered with crayon. The wax crayon will resist the paint, leaving an interesting textural effect of crayon and paint. Dark paint should be used over light colored crayons and light colored paint such as yellow may be used over dark colored crayons for greater contrast. All working surfaces should be covered with newspaper to protect them from crayon marks and paint.

Brush the tempera in one direction. In this design, light tempera is being brushed over dark crayon.

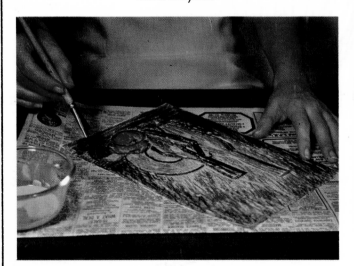

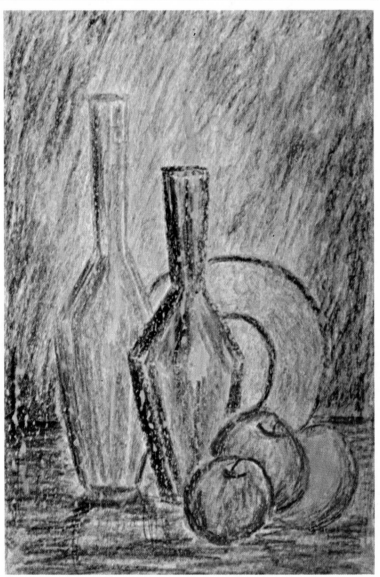

This design was made with light colored crayons and black tempera was brushed over it.

crayon and wax paper transparencies

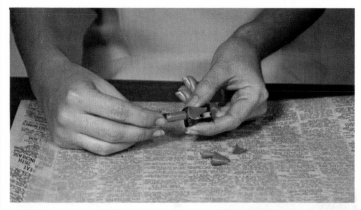

1. Cut two pieces of wax paper the same size. Place one piece of the wax paper on a sheet of newspaper. Make crayon shavings by scraping the crayon with a knife or bobby pin or use a small pencil sharpener.

2. Arrange the colored crayon shavings on the wax paper in a design. A piece of colored yarn may be added if desired.

3. When your design satisfies you, place the second piece of wax paper on top of the crayon shavings, place a sheet of newspaper over it and iron with a warm (not hot) dry iron. The heat will fuse the two pieces of wax paper together and melt the crayon shavings between them. The design may then be matted between a double mat and hung where light will filter through it or you may mount it over a piece of colored paper and frame it.

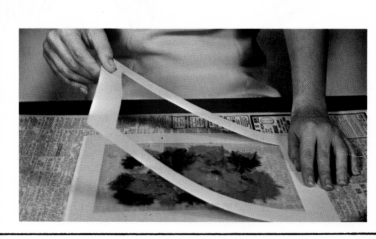

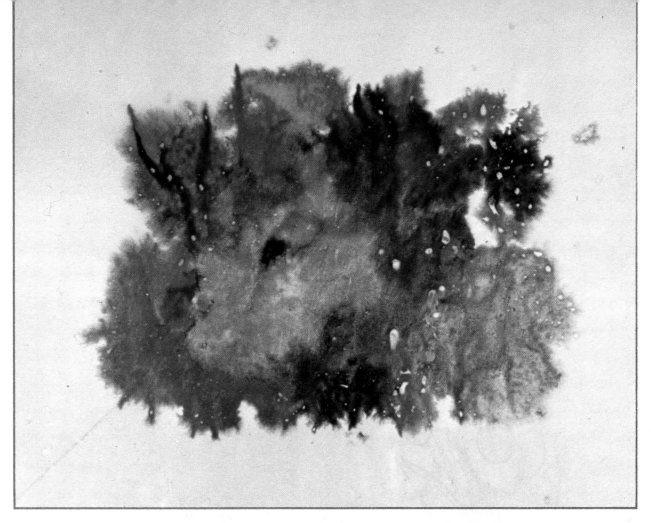

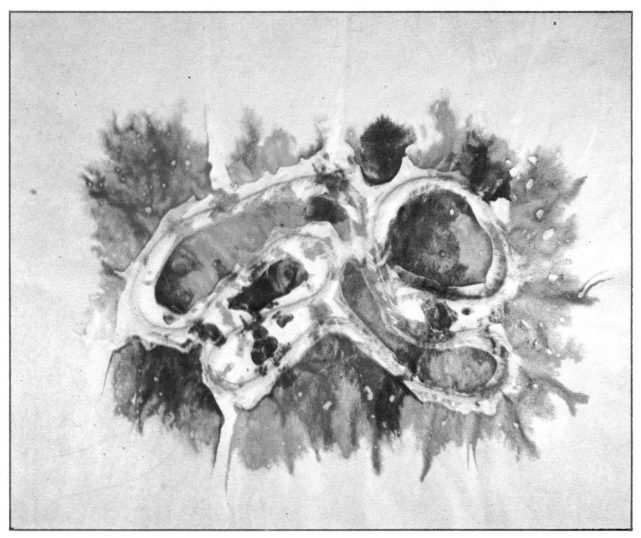

encaustic
(melted crayon)

Encaustic painting involves a method in which wax is combined with colors and made permanent by being fused with heat.

1. A simple method of producing a wax painting is to melt crayons and apply them to a background. This may be done by shaving each color into a section of a muffin tin and placing the muffin tin on a hot plate until the crayon shavings have melted. The colors may be applied to a background of wood, masonite, posterboard or heavy paper with stiff brushes or Q-tips.

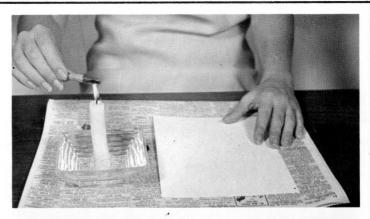

2. An even more simple method of working is to use a lighted candle and hold a peeled wax crayon to the flame until it is soft enough to apply to the background.

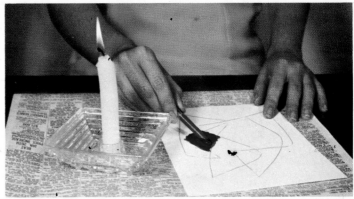

3. It must be applied with a quick stroke and reheated for the next stroke. This method results in a heavy texture. If a smoother effect is desired, when all crayon has been applied, the design may be placed in the noonday sun or in a moderate oven for a few minutes.

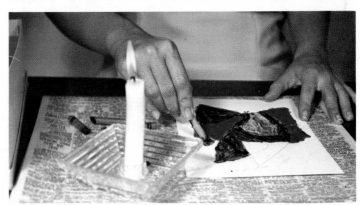

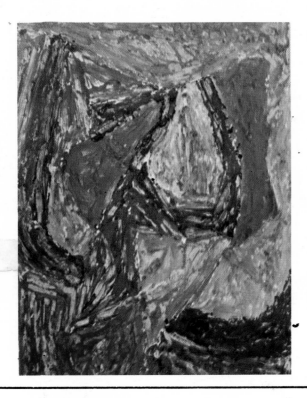

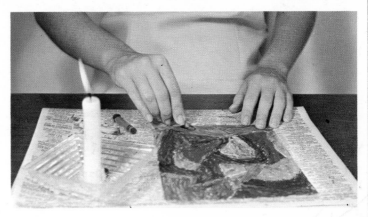

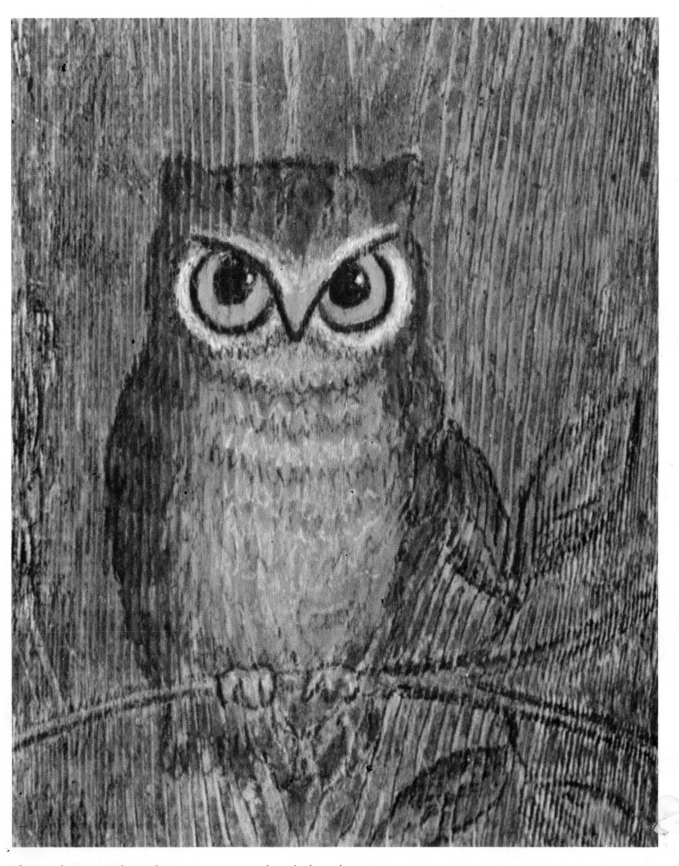

This owl was made with crayon on wood and placed in an
oven for a few moments to fuse the colors into the wood.

crayon drawings on colored paper

If a light colored construction paper is used, it can provide an attractive background for simple crayon drawings. This becomes a fast way to work since the background color does not have to be filled in.

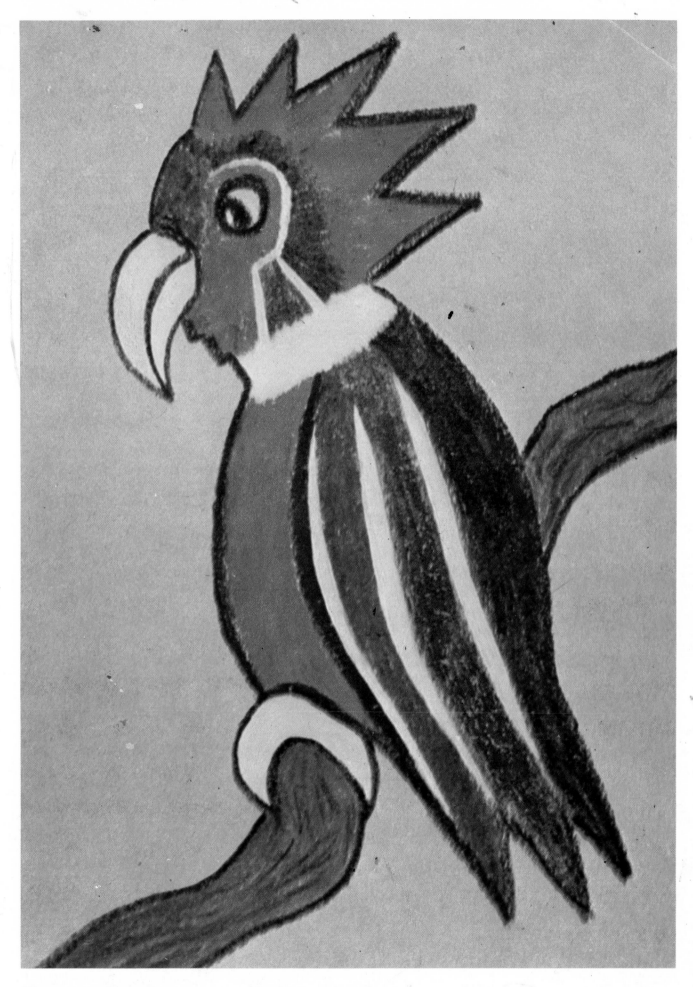

This picture of a parrot was made with crayon and acrylic paint on colored construction paper. The yellow color was painted and all other colors were made with crayons.

These crayon drawings were cut out and adhered with rubber cement to a background of colored paper. The clown was put on wallpaper.

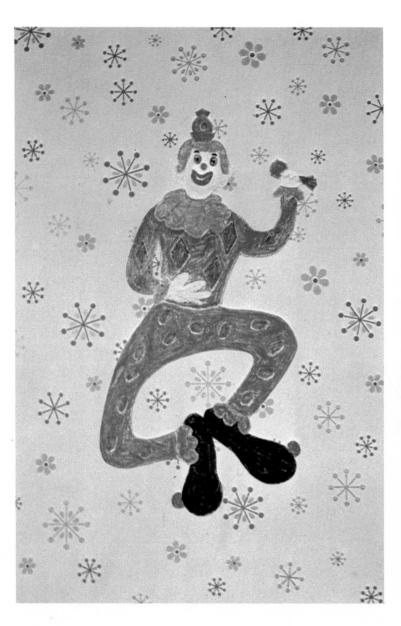

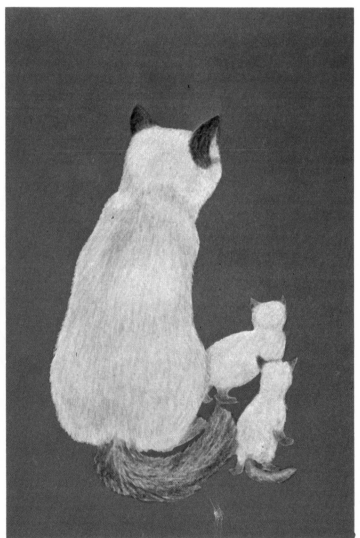

crayon on cloth

Fabric place mats may easily be decorated with crayon. Make a design on paper and transfer it to your place mats. Size 12" x 18" is a good size for place mats. The edges may be hemmed or fringed. Color the design areas with crayon. When the design has been completed, place it between plain white newsprint and iron it from the back side with a hot iron. The heat will make the colors permanent.

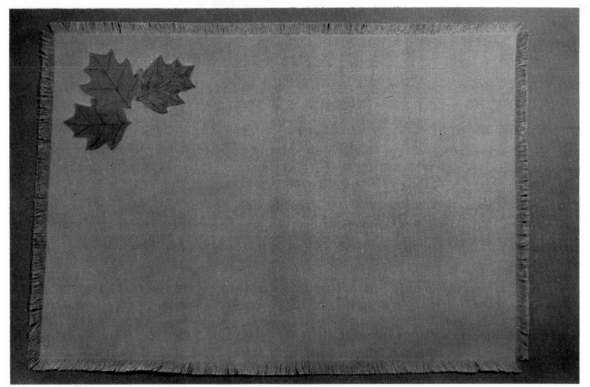

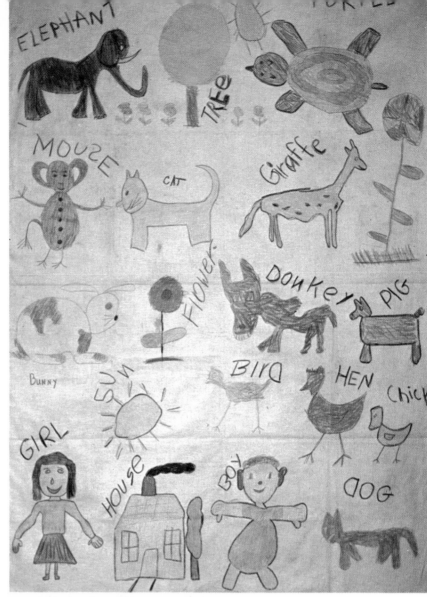

Curtain material for a child's room or a schoolroom may be made by allowing children to draw directly with crayons on muslin. If a permanent finish is desired, the curtains may be ironed. If this is being done in a classroom, the teacher may wish to use the same fabric each year and allow a new group to design the curtains. In this case, the curtains should not be ironed with a hot iron for permanence, then they can be put in a washing machine with bleach at the end of the year and the designs removed so the same curtains may be designed again by a new class.

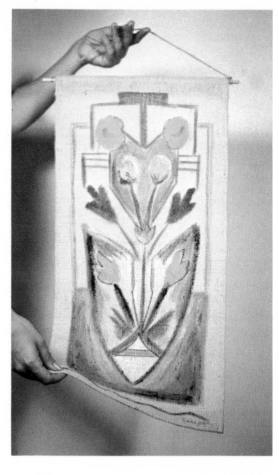

Wall hangings may be made by drawing with crayon on burlap or other fabric and ironing with a hot iron. They may be framed or a hem may be sewn at the top and bottom and pieces of dowel rod inserted for hanging.

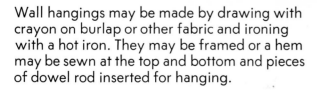

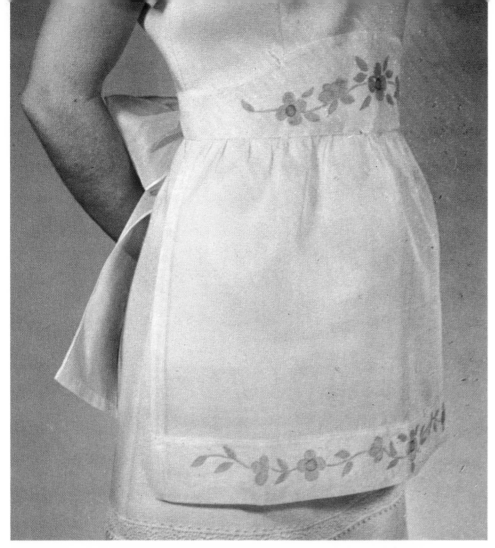

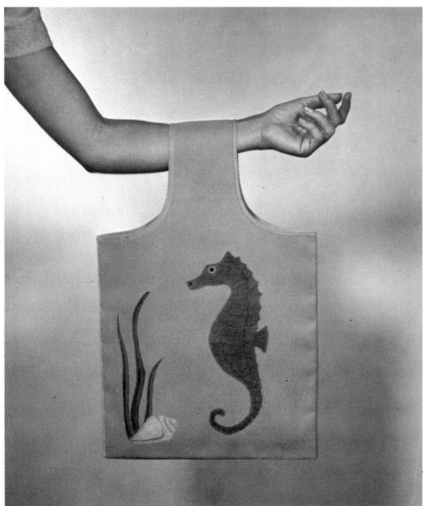

crayon batik

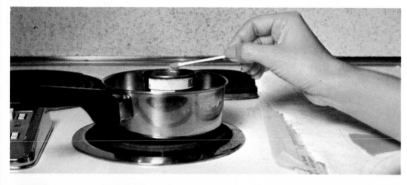

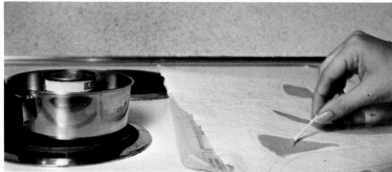

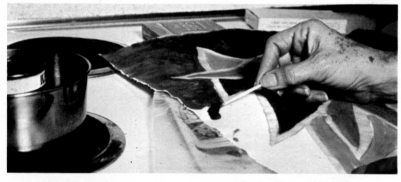

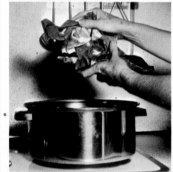 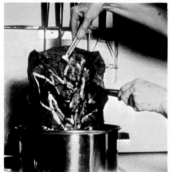

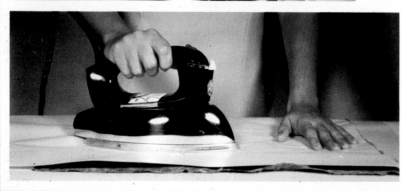

Batik is the technique of making designs on fabric with wax and dyes. Each time the fabric is dipped into a dye bath, a coat of hot wax is put on areas where it is desirable to retain the previous color. An easy way to imitate this technique with only one dye bath is to apply wax crayon, melted with some paraffin wax, to a design on fabric. For each separate color, crayon and paraffin shavings are put into a container and heated. An easy, disposable container may be made from a small can (such as a frozen juice can) which may be placed in a pan of water over low heat. A Q-tip (or cotton on any small stick) makes a good tool for the colored wax application. When the design has been colored to satisfaction, the fabric is crumpled slightly and dipped into a dye bath. It is removed and allowed to dry, then the wax is ironed out by putting the fabric between clean white paper and ironing with a **hot** iron.

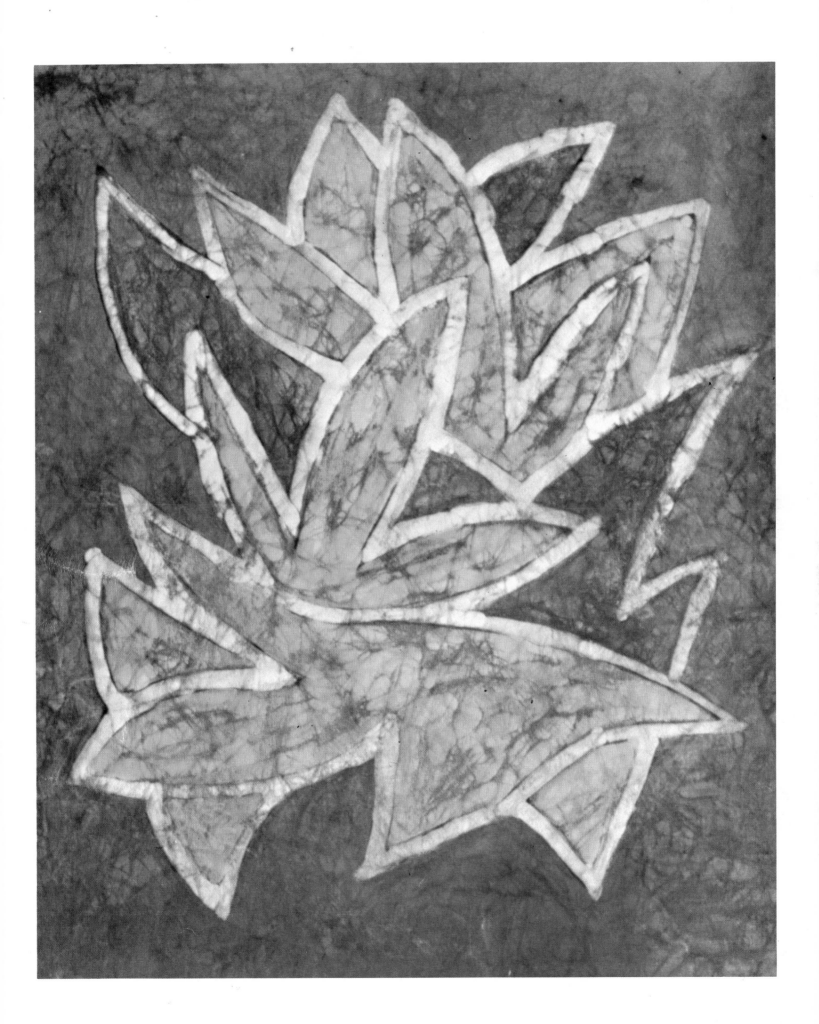

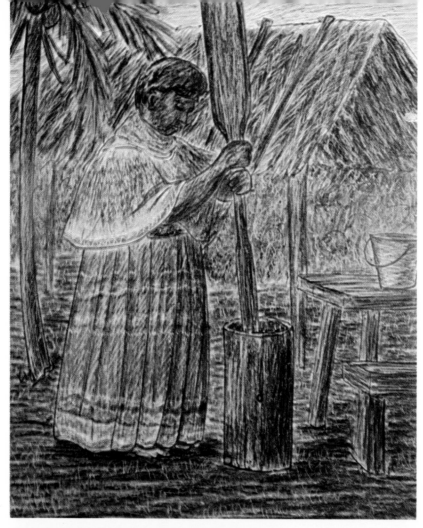

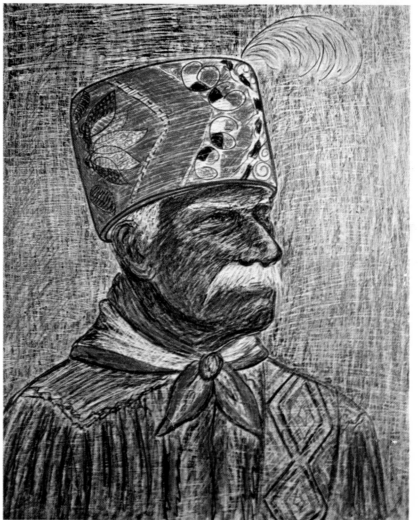

W 1729931

crayon drawing
(alternating layers)

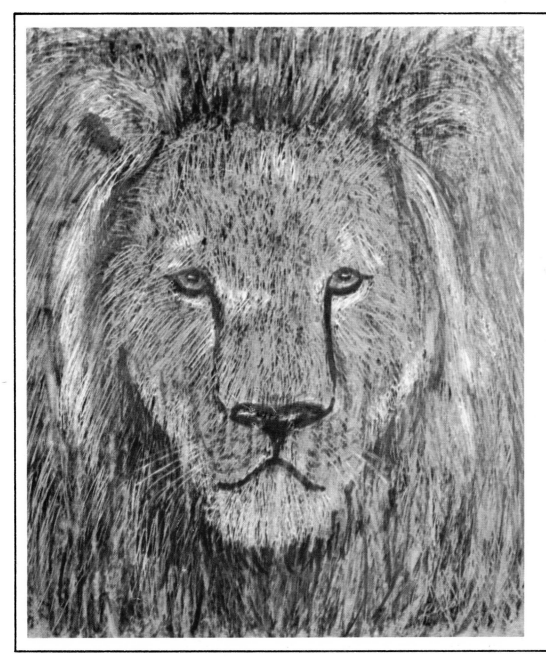

Crayons may be applied over preceding layers of contrasting colors of crayons and a blunt pointed tool such as an orange stick or darning needle may be used to scratch away areas of the top color to expose other colors underneath. The pictures of Seminoles on the opposite page and the lion's head on this page were done by this method.

conte crayon drawings

Conte crayons are short square sticks which are available in black, white, brown and sanguine and may be obtained in varying degrees of softness. The sketch below was made with a brown conte crayon.

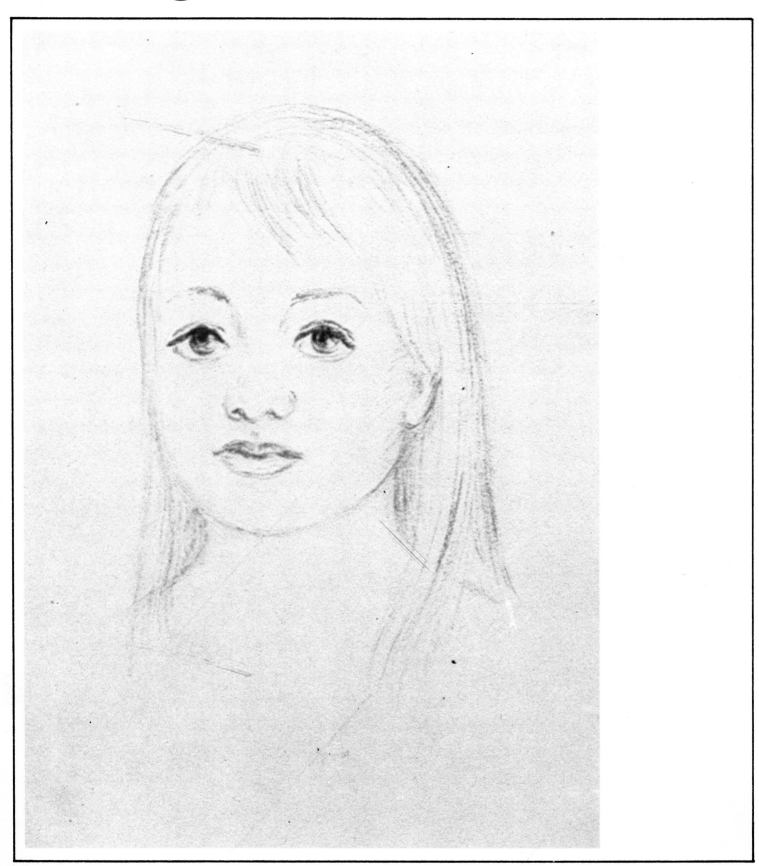

lithograph crayon drawings

Lithograph crayons or pencils are used for drawing in the printing process of lithography. However they may be used for drawing on paper. The lithograph pencil has a core that resembles black wax crayon. The drawings on this page were made with a lithograph pencil.

The sketch of the Colt was made on a background of colored tissue paper laminated with transparent white glue. (See page 31.)

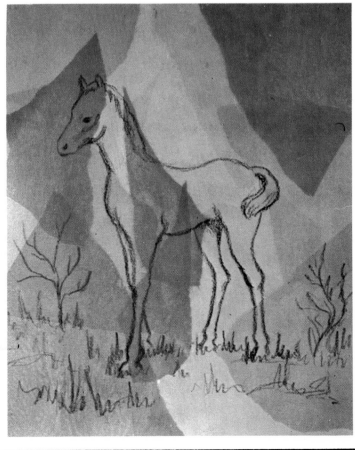

crayon and solvents

Turpentine or mineral spirits are solvents for wax crayon. A permanent painting medium may be made by dissolving crayon shavings in a small amount of turpentine or mineral spirits and applying the color to a background of paper, masonite or wood with a brush. If masonite is used, first apply a coat of white masonry paint or gesso to the smooth side. The same effect of painting may be obtained by drawing with crayons and brushing across each color with a brush or soft cloth which has been dipped into a solvent.

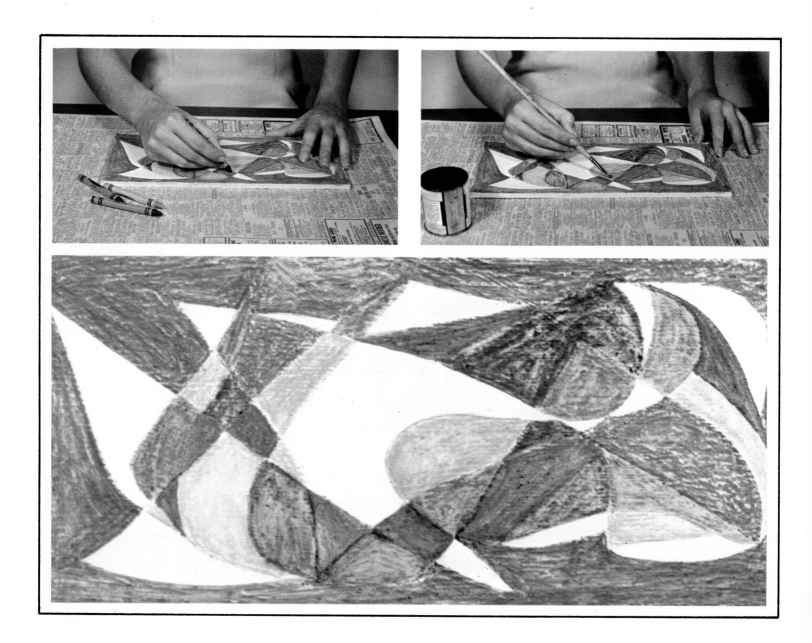

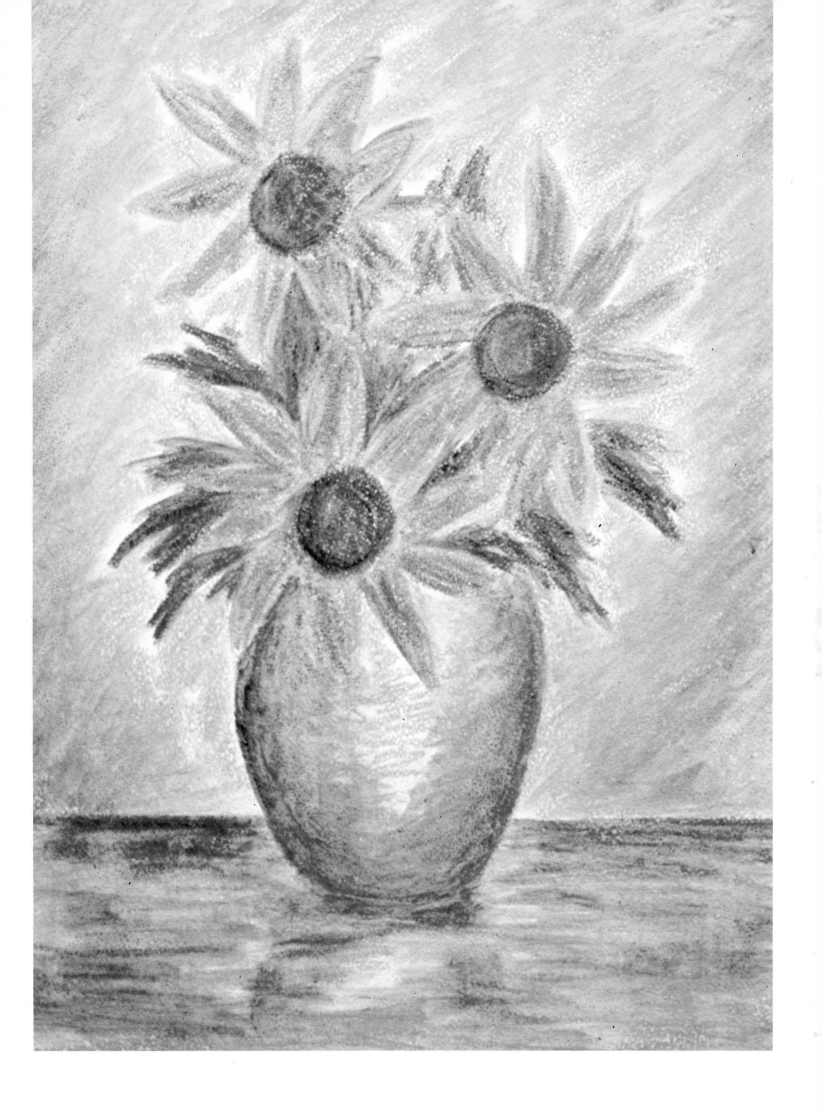

crayon, ink and watercolor

Crayon may be combined with black India ink or it may be combined with both ink and watercolor. For a different and interesting method of working, sketch with black India ink on a piece of heavy white paper which has been dampened with a wet sponge. The ink will spread on the dampened paper. Allow the ink design to dry, then fill in areas with colored crayon. Use transparent watercolors to brush across the crayon and ink to complete your design.

Ink and crayon picture by a 12 year old girl.

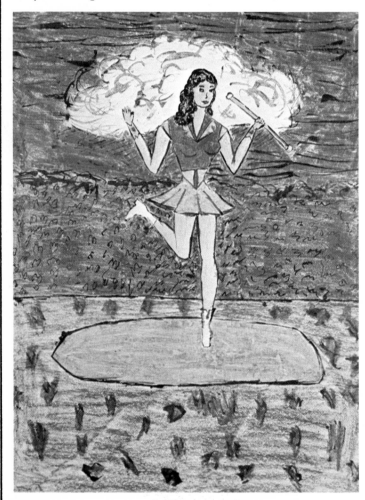

Ink, crayon and watercolor were combined on dampened paper for this picture.

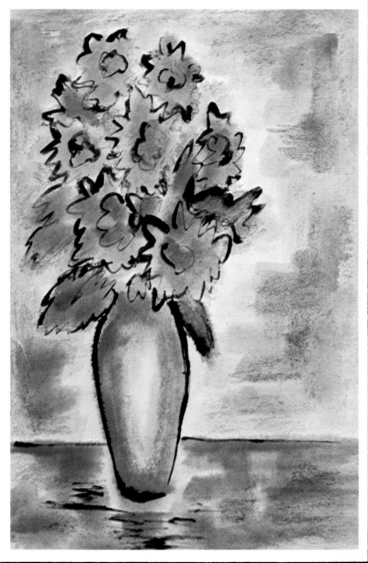

tissue paper and crayon

Laminate colored tissue paper to a background of white drawing paper, tagboard or posterboard with a mixture of 1 part white glue and 1 part water. Brush the mixture on the background and put on torn pieces of tissue paper, allowing the pieces to overlap. Brush the glue mixture over the top of the tissue so all edges will be adhered smoothly. Allow this to dry overnight then use a black crayon to sketch a design across the tissue paper background.

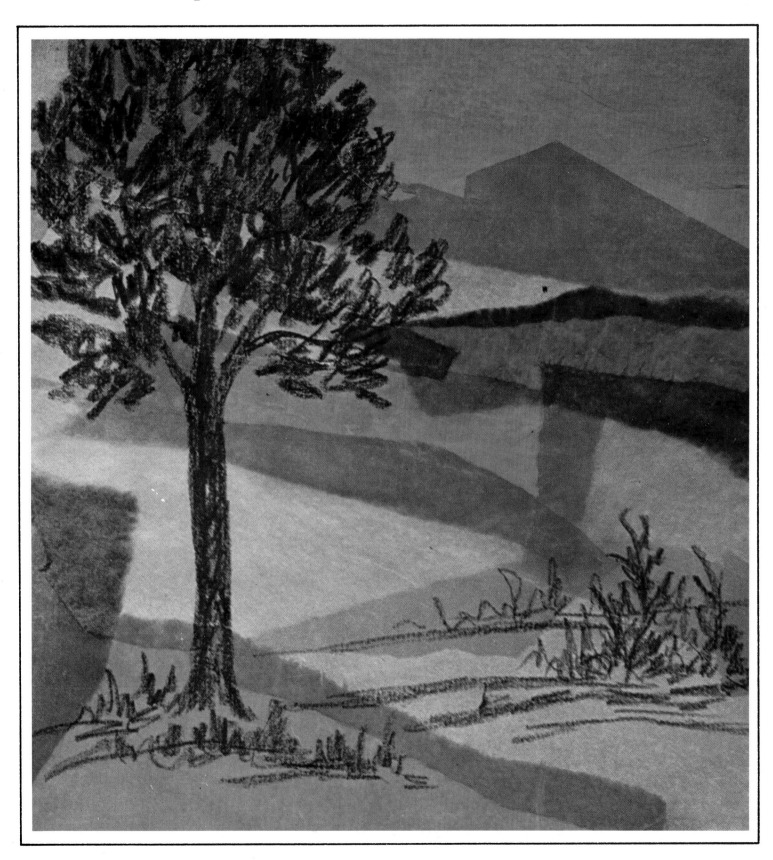

index

Other Dukane Craft/Art books by the authors:
Stitchery — ISBN 0-87800-010-0
Printing Without a Press — ISBN 0-87800-029-1
Jewelry Anyone Can Make — ISBN 0-87800-030-5
Holiday Ideas — ISBN 0-87800-031-3
Ends & Odds to Art — ISBN 0-87800-032-1